KING ALFRED'S COINS

THE WATLINGTON VIKING HOARD

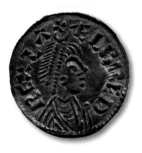

Gareth Williams
& John Naylor

CONTENTS

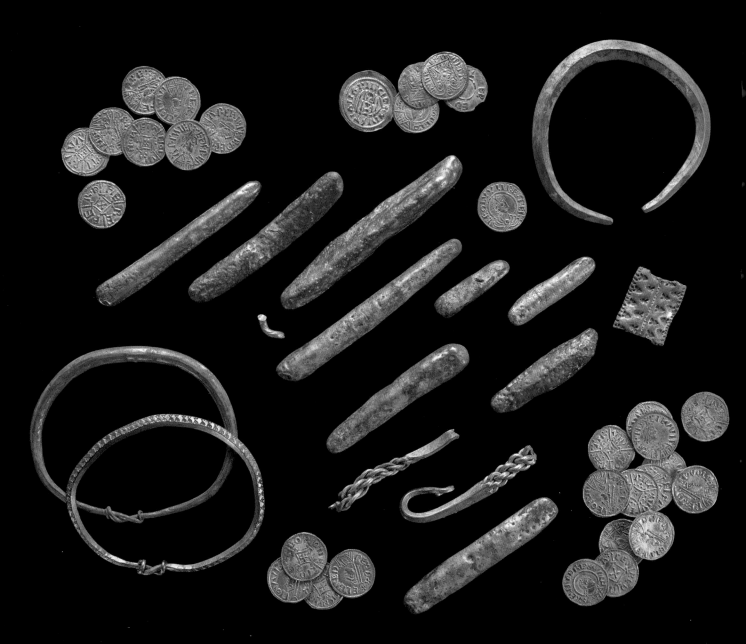

INTRODUCTION

In October 2015, metal detectorist James Mather discovered an important Viking hoard near Watlington in South Oxfordshire. The hoard dates from the end of the 870s, a key moment in the struggle between Anglo-Saxons and Vikings for control of southern England. The Watlington hoard is a significant new source of information on that struggle, throwing new light not only on the conflict between Anglo-Saxon and Viking, but also on the changing relationship between the two great Anglo-Saxon kingdoms of Mercia and Wessex. This was to lead to the formation of a single united kingdom of England only a few years later.

The hoard contains a mixture of Anglo-Saxon coins and Viking silver, and is in many ways a typical Viking hoard. However, its significance comes from the fact that it contains so many examples of previously rare coins of Alfred the Great, king of Wessex (871–99) and his less well-known contemporary Ceolwulf II of Mercia (874–c.879). These coins provide a clearer understanding of the relationship between Alfred and Ceolwulf, and perhaps also of how the once-great kingdom of Mercia came to be absorbed into the emerging kingdom of England by Alfred and his successors.

Oxfordshire lay on the borders of Mercia and Wessex, and Oxford was one of a number of fortified towns developed under Alfred, in part to control the Thames, which like other great rivers offered an important route for Viking ships to strike into the heart of England. The Viking forces moved by both water and land, and the ancient trackway known as Icknield Street passes through the area around Watlington, close to where the hoard was found. The Watlington hoard thus offers new insights into the history of the region. It is a find of enormous local importance, and one of the most significant discoveries of the period ever made in Oxfordshire. At the same time, as a major new source of information about the expansion of Wessex into the new kingdom of England, this is a find of truly national importance.

Fig 1. A selection of items
from the Watlington Hoard,
illustrating the range of objects
discovered.

DISCOVERY AND CONSERVATION

On 7 October 2015, James Mather was metal-detecting on a field near Watlington, Oxfordshire with the permission of the landowner. He had been working for several hours but had found little more than ring pulls and shotgun cartridges. Thinking he would give up for the day he picked up a strong signal and, digging into the soil, discovered a thin cigar-shaped object about six centimetres in length made from silver. James had seen similar objects on a visit to the British Museum and immediately recognised that it was a Viking-Age ingot (bar). Carefully detecting in the surrounding area, James picked up another signal a few metres away. Digging down he started to find silver pennies and realising that he had discovered a hoard he called archaeologist David Williams and the landowner. David works for the Portable Antiquities Scheme (PAS), a project funded via the British Museum to encourage the recording of archaeological finds made by members of the public. As the Finds Liaison Officer for Surrey and East Berkshire he is responsible for recording many local finds, and James regularly reports discoveries to him. After discussion with David, James carefully removed the coins which had been uncovered, as David was unable to visit the site that day. Once he'd done this, James found that he was still getting a strong signal from the small hole and so he and David agreed to return to the site to excavate the find archaeologically. As well as reporting finds to David, James often attends the Ashmolean Museum's Identification Service. Knowing that he had to report his find as potential Treasure (under the Treasure Act 1996) and that the Ashmolean is home to the PAS's National Finds Advisor for Medieval Coinage, James contacted the Museum and was able to deposit the objects that he had already found the following day.

A few days later, James met David and one of his colleagues at the findspot along with the landowner

Fig 2. James Mather, finder of the Watlington hoard.

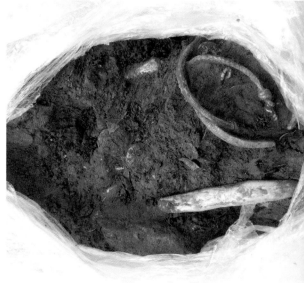

and together they excavated the rest of the hoard. James had backfilled his initial excavation and David decided to excavate a 1.5 metre square trench around this. Once he had removed the ploughsoil, the hoard could be seen as a dark stain within a flinty clay subsoil. David carefully cleaned around the hoard in order to uncover its full extent, a compact thirty centimetres by ten centimetres. From here, he started to define the objects and he could see that it consisted of coins, arm-rings and ingots. A couple of ingots were found to the side of the main group where they had been moved by ploughing, but the bulk of the hoard was in a small, intact group. Realising that the coins were very brittle or already broken into fragments, David decided to lift the hoard as a block and have it excavated under laboratory conditions. To do this, he removed the soil surrounding the hoard to leave it standing as an island, wrapped it in cling film, and moved it onto a metal tray before placing it into a plastic box. The hoard was taken to London to be excavated by Pippa Pearce, Senior Conservator in the British Museum's Department of Conservation and Scientific Research.

⊙ Fig 3. David Williams and Emma Corke excavating the small trench around the hoard.

⊙ Fig 4. The soil block wrapped in clingfilm just after delivery to the British Museum. Some of the armrings, an ingot and coins are visible on the top of the block.

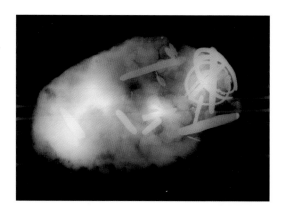

Pippa's first task before starting to excavate the block was to assess what it contained. This was achieved using x-ray which revealed the internal structure of the block. A concentration of objects was visible – coins, arm-rings and ingots – at one end of the block, with more coins and ingots spread out within the remaining space, indicating that over time it had become quite mixed in with the surrounding soil, no doubt having been affected by both natural processes after burial

⊙ Fig 5. X-ray of the soil block before its excavation at the British Museum. A tightly packed cluster of armrings, ingots and coins is clearly visible at the right-hand end. The spread of objects towards the left-hand end, including an ingot is one of the ways that the team could tell that the hoard was becoming dispersed in the ground.

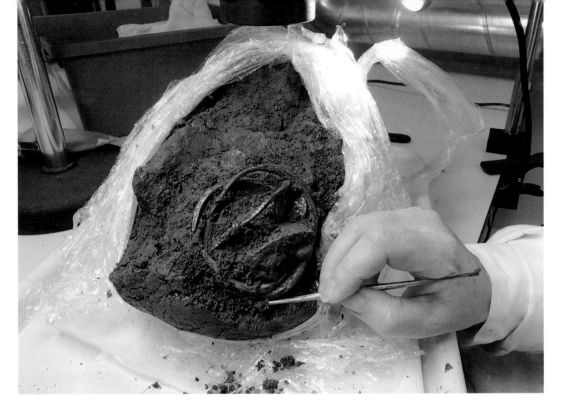

Fig 6. One of the conservation team carefully removing soil from the block to reveal the objects in the hoard.

and ploughing. There was no evidence remaining to suggest how the hoard had been put together. Pippa and her team carefully excavated the block in layers, photographing each layer before removing the objects and continuing excavation. This allowed them to record the internal arrangement of the hoard as it was excavated. Such a technique had proven very informative for other hoards such as the Roman coin hoard from Beau Street, in Bath, where individual money bags could be clearly seen. Unfortunately, the initial conclusions drawn from the x-rays were correct and the hoard, although remaining intact, had been disrupted in the ground to the extent that its original configuration is almost entirely lost. This can be seen clearly in the case of two fragments from the same coin – one was found outside of the hoard while the other was excavated from the centre of the block indicating that the coin had become broken and dispersed within the ground over time. There were quite a few other

coins which were also only found as fragments, some of which the conservation team have been able to reassemble, but many are complete with clear designs and inscriptions. The thick clay surrounding the coins and objects was carefully removed and the work of the finds specialists could then begin.

After the excavation of the soil block was completed, work began assessing its contents and writing a catalogue of finds for the Coroner's Report. All cases of potential Treasure have to be assessed by the local coroner who decides whether the find constitutes the legally-defined terms of treasure under the Treasure Act 1996. The writing of the Coroner's Report is a very important part of this process. John Naylor, the PAS National Finds Advisor at the Ashmolean Museum, and Gareth Williams, a curator at the British Museum, examined the coins while Barry Ager, another British Museum curator, examined the other objects.

THE HOARD

In total the hoard contained around 200 complete silver coins plus fragments, seven items of jewellery – consisting of complete silver arm-rings, a number of deliberately cut fragments, known as hack-silver (see p. 11), and fifteen silver ingots. How does this compare to other Viking hoards which have been found in England? The mixture of coins, intact jewellery, hack-silver and ingots is typical of the mixed hoards of the Vikings, who continued to value silver by weight long after they settled in England (see p. 16) and started to mint coins of their own. It is certainly nowhere near as large as some, for instance, the Vale of York hoard (617 coins, 68 other silver and gold objects) or the Cuerdale hoard, the largest Viking hoard from England, which contained around 7,500 coins and 1,000 other objects. It is, however, comparable with medium-sized hoards such as Silverdale (27 coins, 174 other objects) or Croydon (a nineteenth-century find of around 250 coins together with a number of ingots and hack-silver). The importance of the Watlington hoard, then, lies not so much in its size but in its content, its date and its findspot. The latter two are discussed later in this book. Here we will focus on the finds themselves.

COINAGE

The coins found in the hoard date to a very narrow period of time during the later 870s during the reigns of Alfred the Great, king of Wessex from 871–99, and his contemporary Ceolwulf II, king of Mercia from 874–c.879. The coins are a combination of issues by both Alfred and Ceolwulf, along with two of Æthelred,

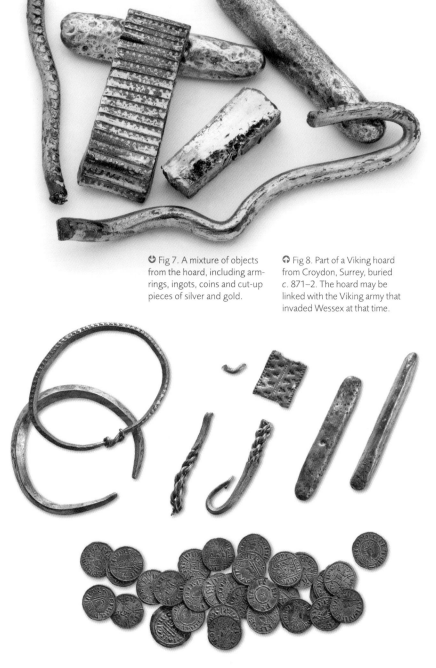

◐ Fig 7. A mixture of objects from the hoard, including arm-rings, ingots, coins and cut-up pieces of silver and gold.

◑ Fig 8. Part of a Viking hoard from Croydon, Surrey, buried c. 871–2. The hoard may be linked with the Viking army that invaded Wessex at that time.

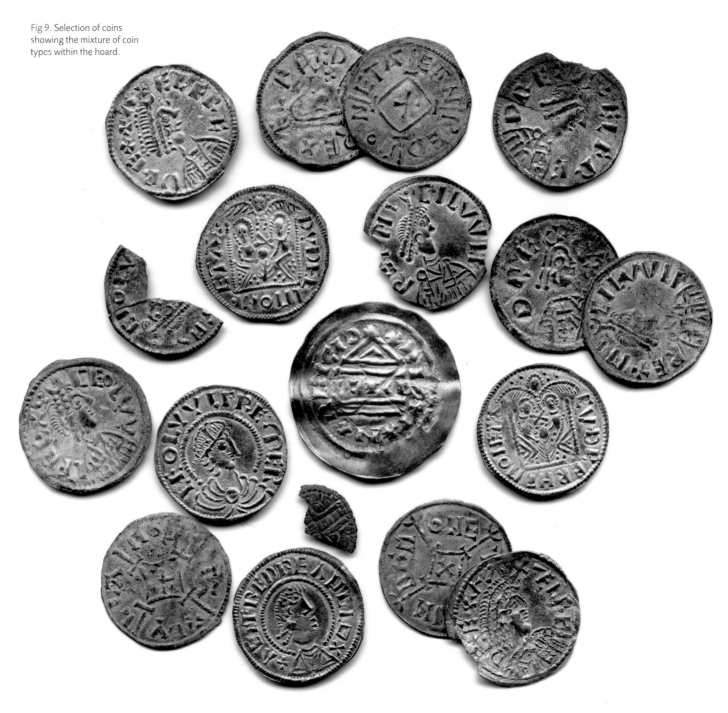

Fig 9. Selection of coins showing the mixture of coin types within the hoard.

Archbishop of Canterbury from 870–89 and two silver deniers from the kingdom of the Franks which included modern France, Germany, northern Italy, Switzerland and the Low Countries. Finds of Anglo-Saxon coins of this particular period are very rare, turning up occasionally in hoards or as single finds, and so a hoard consisting almost entirely of such issues is a very important find, and roughly quadruples the known corpus of coins of this date. All of these coins are pennies, bar one fragmentary halfpenny. The coins can be divided into two main groups based on their designs – the 'Two Emperors type' and the 'Cross-and-Lozenge type'. What is interesting about these two groups is that coins of both Alfred and Ceolwulf were issued using the same designs, leading scholars to suggest that the kings may have had an alliance, something which would be difficult to tell from the historical documents. A third design, known as the 'Two-Line type', is represented by a single coin, and there is also an intriguing halfpenny.

TWO EMPERORS TYPE

Undoubtedly the most spectacular coins in the hoard are those of the 'Two Emperors type', so-called because of the design on the reverse (tail side) of the coin. Only two examples have been published previously, one each of Alfred and Ceolwulf, and so the discovery of thirteen more is remarkable, consisting of ten of Alfred coins and three of Ceolwulf. We will be able to understand much more about the 'Two Emperors type' coins from these new finds. For instance, it was suggested before that Alfred's coins of this type were minted in London, and the new finds support this, with the moneyers named on the coins all known from earlier types produced in London for Alfred or his Mercian contemporary Burgred. This also suggests that the 'Two Emperors type' coins are the earliest Anglo-

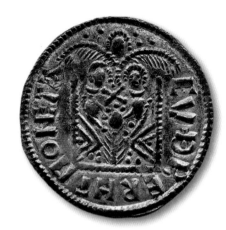

⇨ Fig 10. Reverse of the 'Two Emperors type' from the hoard, carrying the name of the moneyer Cuthberht. The design was copied from Roman coins, but its significance for the Anglo-Saxons remains the subject of debate.

↻ Fig 11. Silver pennies of the 'Two Emperors type' in the name of Alfred (moneyer Beagstan) and Ceolwulf II (moneyer Hereferth).

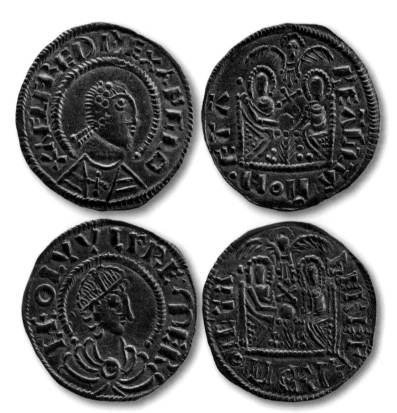

Saxon coins in the hoard. The reverse design of the coin showing two emperors seated below the winged figure of Victory copies Roman gold solidi dating to the late fourth century, and some scholars have argued that as they are relatively common finds in England it is difficult to know if the motif was copied because the iconography was meaningful at this time, or if it was simply a part of the wider adoption of Roman designs (Roman busts were more often copied). However, many see this design as an illustration of the alliance between Alfred and Ceolwulf against the Viking threat, perhaps under divine protection (see pps 26–27).

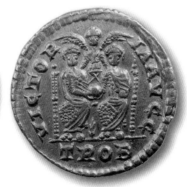

↻ Fig 12. A late fourth-century Roman gold solidus of the type used as the prototype for the 'Two Emperors type' pennies of Alfred and Ceolwulf II. This one is of the Emperor Magnus Maximus (383–88) from the mint at Trier (Germany).

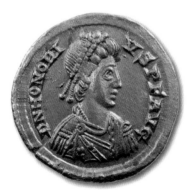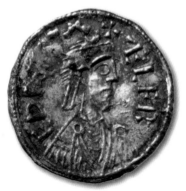

↻ Fig 13. Obverse of a 'Cross-and-Lozenge type' silver penny of Alfred the Great which closely copies the bust seen on Late Roman gold solidi. The Roman coin pictured here as an example is of the Emperor Honorius (395–423) from the mint at Rome.

CROSS-AND-LOZENGE TYPE

The hoard contained around 180 'Cross-and-Lozenge type' coins (plus fragments), constituting the vast majority of coins found. Before the discovery of the Watlington Hoard only about sixty were known. The name is derived from the reverse design showing a long-armed cross with a large lozenge at its centre, itself enclosing another cross (see Fig 44 on p.27). The inscription around the outside gives the name of the moneyer. Like the 'Two Emperors type', the obverse (heads side) copies late fourth–early fifth-century gold Roman solidi, some of which are so close to the original Roman coin that the die cutters may have had an example in front of them. Numismatists have divided the 'Cross-and-Lozenge type' coinage into three main styles based around the names of the moneyer, the spelling of the king's names, and aspects of the bust design. These 'styles' have been broadly attributed to mints at Canterbury, London, and Winchester, plus a few others possibly including one in western Mercia (roughly the modern Midlands). As our work progresses we hope to test how well these styles work with the new coins, and gain a better understanding of the 'Cross-and-Lozenge type' in general, including the number of mint locations and their chronology. Already we have found examples of a variety of 'Cross-and-Lozenge type' – known previously only from a very corroded coin found during excavations in Southampton – which may show its development from earlier types.

TWO-LINE TYPE

A single example of Alfred's 'Two-Line type' was found in the hoard, but it is important for our understanding of the date of the hoard. This type, with its comparatively plain non-portrait design simply naming the king (Alfred) on the obverse and the moneyer on the reverse was most likely not produced until at least the very late 870s. As the latest coin in the hoard, it gives us the earliest possible date for its deposition, known to scholars as its *terminus post quem*.

THE HALFPENNY

An intriguing find from the hoard is what appears to be a halfpenny, possibly of Alfred. This has an open cross on the reverse although no other details are can be gleaned from the coin owing to its poor condition. This design is recorded on pennies of Alfred's father Æthelwulf and brother Æthelberht, but has not previously been associated with coins of Alfred or Ceolwulf II. What makes the coin special is that it appears to be a new type, not previously known, and it may also be the earliest round halfpenny produced in Anglo-Saxon England, with the earliest previous example being a halfpenny of Ceolwulf II of the 'Cross-and-Lozenge type'. Unfortunately, given its condition, we cannot say much more about the coin with certainty.

CAROLINGIAN DENIERS

The last two coins in the hoard are Frankish deniers, roughly equivalent to the Anglo-Saxon penny albeit slightly heavier. Both are of the 'Christiana Religio' group, named after the reverse inscription, a common Frankish coin type, which was produced

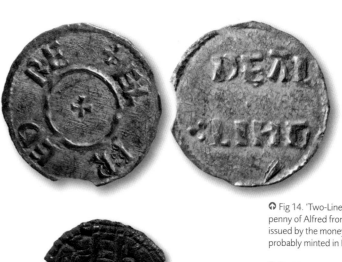

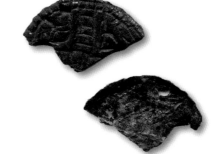

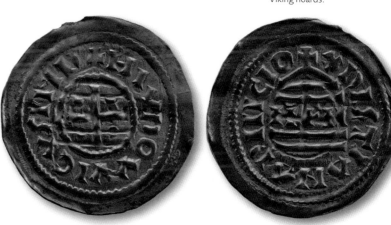

↺ Fig 14. 'Two-Line type' penny of Alfred from the hoard, issued by the moneyer Dealing, probably minted in London.

↶ Fig 15. Fragmentary halfpenny from the hoard. Voided Cross type, possibly issued by Alfred the Great. It may be the earliest surviving English halfpenny of any type.

↻ Fig 16. Frankish denier of the Christiana Religio type, typical finds in ninth-century Viking hoards.

for around forty years under several rulers. They are not uncommon finds in ninth and tenth-century Viking hoards in England and are also occasionally found as single finds.

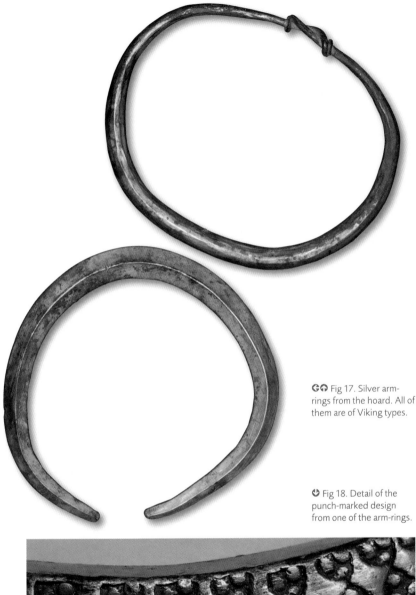

Overall, the coins in the Watlington hoard provide a remarkable insight into the coinage of the later 870s, greatly increasing the number of finds available for researchers to study. We hope that this will help us to understand better a number of factors relating to the coinage of the period including the order that the types were produced in, their length and size of production, and their mint places. This will enable us to more accurately date and understand the Watlington hoard itself.

OTHER OBJECTS

Apart from the coins, the hoard also contained both complete and fragmentary objects of precious metal. The most striking of these are three intact silver arm-rings. All three are in different styles, but all are typical of Viking workmanship. One is a simple square-ended rod with a lozenge-shaped section, curved to fit around the wrist, with parallels in Viking hoards from northern England, Scotland, and the Isle of Man. A second ring also has a lozenge-shaped section, but tapers towards the two ends, which are twisted around each other to make a complete ring. This ring is also decorated on the two outer faces with a punched design of repeated triangles, with three pellets within each triangle. Punch-marked designs in general and the triangle and pellets in particular are characteristic features of Viking arm-rings from Britain and Ireland from the late ninth and early tenth centuries. The final arm-ring is of round section, again with the two ends twisted together. This is a typical Scandinavian design of the ninth and tenth centuries. Precious metals were mostly used in the Viking Age for the display of personal wealth in the form of jewellery and ornaments. The giving of arm-rings in particular was a symbol of the bond between a leader and his followers, as they served as a visible reminder of the loyalty and service that had led to such a valuable reward.

⤴⤴ Fig 17. Silver arm-rings from the hoard. All of them are of Viking types.

⟳ Fig 18. Detail of the punch-marked design from one of the arm-rings.

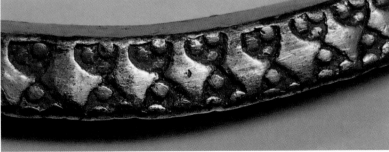

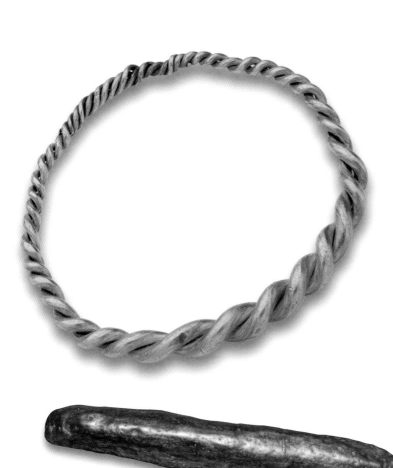

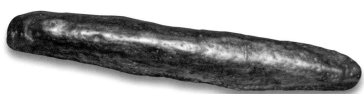

Fig 19. Gold arm-ring from Brightlingsea, Essex. Silver arm-rings were valued as visible rewards for loyal service, but gold was even more highly prized.

Fig 20. Silver ingots formed a convenient way of storing silver in the Viking age. They could be used as they were for large payments, or cut up into smaller fragments. They could also be hammered out to form arm-rings, or melted for use in other types of jewellery.

Fig 21. Hack-silver, cut from a neck-ring of twisted rods and from an arm-ring, both of Viking types.

The hoard also contains three pieces of cut or broken silver (two from brooches, one from an arm-ring), fifteen silver ingots (bars), and a single cut piece of gold rod. Although imported coins were known in Scandinavia before the Viking age, they were extremely rare, and their use was largely limited to trading centres and a few wealthy estates which also had contact with foreign traders. However, the Viking expansion of the late eighth and ninth centuries brought the Vikings into contact with coin-using economies both in Anglo-Saxon England and the Frankish kingdoms in the west, as well as the Byzantine empire and Islamic caliphate in the east.

From these the Vikings borrowed the idea of using precious metal as currency. Rather than minting coins of their own, they preferred to value silver by weight and purity. Ingots provided a more convenient way of storing and carrying larger quantities of silver than smaller pieces, but it was also common to cut up ingots, jewellery, and even coins to create what is known as hack-silver. This was very flexible, since people just cut silver to the size and weight required, from tiny pieces much smaller than coins, to ingots weighing several kilogrammes, effectively creating a wide range of denominations.

The quality of the silver was tested by a variety of methods. One of the most common is known as 'nicking'. This involved cutting into the edge of an object with the blade of a knife. Mixing silver with different metals made it either harder (copper) or softer (lead) to cut, and this method also revealed plating over a base-metal core. Several of the objects from the Watlington hoard show this type of edge nicking. Gold was more highly valued than silver, and was rarer

as bullion. The piece of hack-gold in the Watlington hoard is extremely rare, although both gold ingots and hack-gold are known. Interestingly, the dateable parallels for the use of hack-gold in England come from the 870s, with a few pieces from the Viking winter-camp of 872–3 at Torksey in Lincolnshire, and others from another Viking site in Yorkshire dating a couple of years later. This suggests that hack-gold may have been more common in this period than later in the Viking Age. Even so, the piece from the Watlington hoard is the only example currently known from a hoard otherwise wholly composed of silver.

The mixture of coins, intact jewellery, and bullion is typical of the mixed hoards of the Vikings, who retained the use of bullion long after they settled in England (see p. 17) and started to mint coins of their own. Much of the material in the hoard can only be roughly dated, but the coins offer a much more precise dating. The bulk of the coins in the hoard date from the reign of Ceolwulf II of Mercia (874–c.879), whether they are Mercian or West Saxon issues.

The Two-Line penny (see p. 9) is the sole example of the phase of coinage which followed, in which Alfred issued a standard coinage across Mercia, Wessex, and Kent, together with a few special issues relating to the establishment of individual towns. Alfred's new coinage completely replaced the previous phase in areas of Anglo-Saxon control, and was minted in large quantities. A single example therefore suggests that the hoard was buried very quickly after the new coinage began to be issued – late enough for one example to be included, but too early for the new type to have become common. This suggests a date of c.879–80, which places the hoard at a pivotal time in relation both to Viking activity and to the expansion of Alfred's power and the unification of England.

⊙ Fig 22. Single find of hack-gold from East Hendred, Oxfordshire.

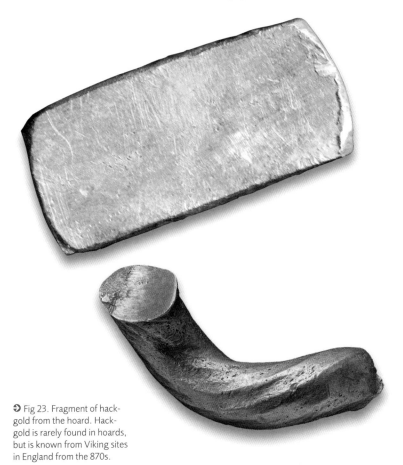

➲ Fig 23. Fragment of hack-gold from the hoard. Hack-gold is rarely found in hoards, but is known from Viking sites in England from the 870s.

THE VIKINGS IN ENGLAND

The term Viking is often used as a general term to describe the Scandinavian peoples from *c*.750–1100. The term is convenient because the modern kingdoms of Denmark, Norway, and Sweden only took shape in the course of the Viking Age. For much of this period these areas were divided into many smaller kingdoms, and contemporary sources are seldom specific about exactly where particular groups or individuals originated. Terms such as 'Danes' and 'Northmen' were used very imprecisely, together with other terms such as 'heathens', 'pagans', and 'pirates'.

Recent scholarship has emphasised the many peaceful achievements of the 'Vikings' in this broad sense, including their craftsmanship, their skills in shipbuilding and seamanship, and their important role in the development of towns and long-distance trade. However, *víkingr* in Old Norse and *wícing* in Old English meant 'pirate' or 'raider', and it was their raiding activity that primarily attracted the attention of contemporary Anglo-Saxon chroniclers, not least because most of the early attacks focused on churches and monasteries, which were regarded as untouchable within a Christian society, but which provided easily accessible and poorly defended concentrations of wealth for coastal raiders.

➔ Fig 24. Excavation of the Viking settlement at Coppergate, York. The Vikings developed towns in northern England, Ireland and Russia as well as in their Scandinavian homelands.

→ Fig 25. Tenth-century carving of a warrior from St Andrew's Church, Middleton, North Yorkshire. This is one of the best surviving contemporary representations of a Viking warrior, and shows him equipped with sword, spear, axe, knife, helmet and shield.

The earliest account of a Viking raid in England, recorded in the *Anglo-Saxon Chronicle* for 789, may have been a trading expedition which became violent, but an attack on the Northumbrian monastery of Lindisfarne in 793 was clearly a planned raid, and was followed by a series of assaults on monasteries around the coasts of Britain and Ireland. Not all of these are recorded in detail, but Kentish charters from the 790s onwards also record military service against 'seaborne pagans', indicating otherwise unrecorded raids.

Most early attacks seem to have been on a fairly small scale, and relied in part on the Vikings' abilities to strike suddenly and effectively from the sea and disappear again before defensive forces could be mustered. Some early assaults were probably more prolonged, and both Kentish and Irish sources suggest the use of temporary fortified camps. Even so, raiding in this period was limited to the sailing season from spring through to early autumn.

The early to mid-ninth century saw Viking fleets increase in size from a handful of ships to tens and then hundreds of ships, carrying thousands of men. These were large enough to face the armies of whole kingdoms on equal terms, although they typically preferred looting and extortion to the risks of battle. They also adopted a new strategy of overwintering in hostile territory, establishing winter camps from which they could continue to raid to re-supply themselves, or in some cases agree truces with native rulers which allowed them to stay peacefully over the winter, even in areas in which they had just been raiding.

Another increase in Viking raids occurred in 865. In that year a force described as a *micel here* landed in the kingdom of East Anglia, and 'made peace' over the winter. *Micel here* is normally translated as 'Great Army',

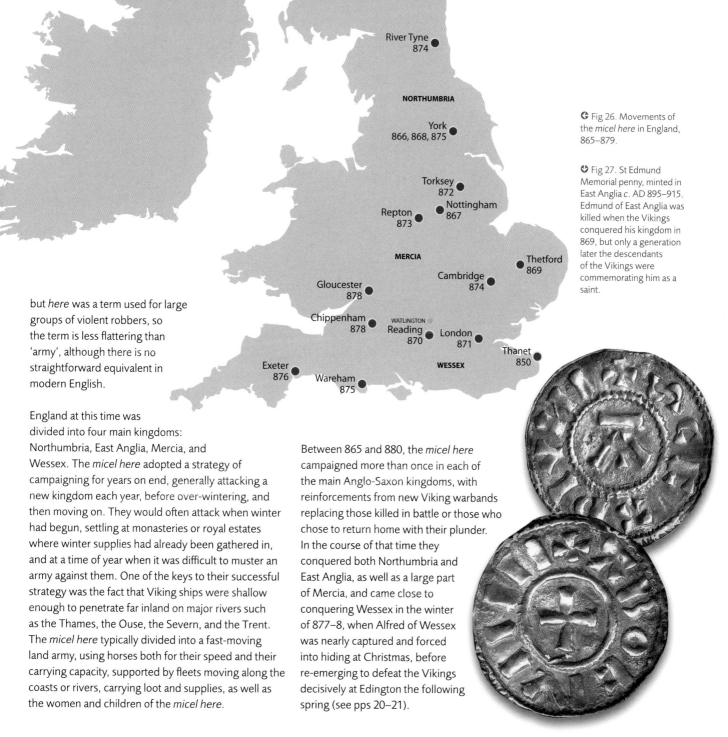

River Tyne
874

NORTHUMBRIA

York
866, 868, 875

Torksey
872

Nottingham
867

Repton
873

MERCIA

Thetford
869

Gloucester
878

Cambridge
874

Chippenham
878

WATLINGTON

Reading
870

London
871

Thanet
850

Exeter
876

Wareham
875

WESSEX

G Fig 26. Movements of
the *micel here* in England,
865–879.

U Fig 27. St Edmund
Memorial penny, minted in
East Anglia *c*. AD 895–915.
Edmund of East Anglia was
killed when the Vikings
conquered his kingdom in
869, but only a generation
later the descendants
of the Vikings were
commemorating him as a
saint.

but *here* was a term used for large groups of violent robbers, so the term is less flattering than 'army', although there is no straightforward equivalent in modern English.

England at this time was divided into four main kingdoms: Northumbria, East Anglia, Mercia, and Wessex. The *micel here* adopted a strategy of campaigning for years on end, generally attacking a new kingdom each year, before over-wintering, and then moving on. They would often attack when winter had begun, settling at monasteries or royal estates where winter supplies had already been gathered in, and at a time of year when it was difficult to muster an army against them. One of the keys to their successful strategy was the fact that Viking ships were shallow enough to penetrate far inland on major rivers such as the Thames, the Ouse, the Severn, and the Trent. The *micel here* typically divided into a fast-moving land army, using horses both for their speed and their carrying capacity, supported by fleets moving along the coasts or rivers, carrying loot and supplies, as well as the women and children of the *micel here*.

Between 865 and 880, the *micel here* campaigned more than once in each of the main Anglo-Saxon kingdoms, with reinforcements from new Viking warbands replacing those killed in battle or those who chose to return home with their plunder. In the course of that time they conquered both Northumbria and East Anglia, as well as a large part of Mercia, and came close to conquering Wessex in the winter of 877–8, when Alfred of Wessex was nearly captured and forced into hiding at Christmas, before re-emerging to defeat the Vikings decisively at Edington the following spring (see pps 20–21).

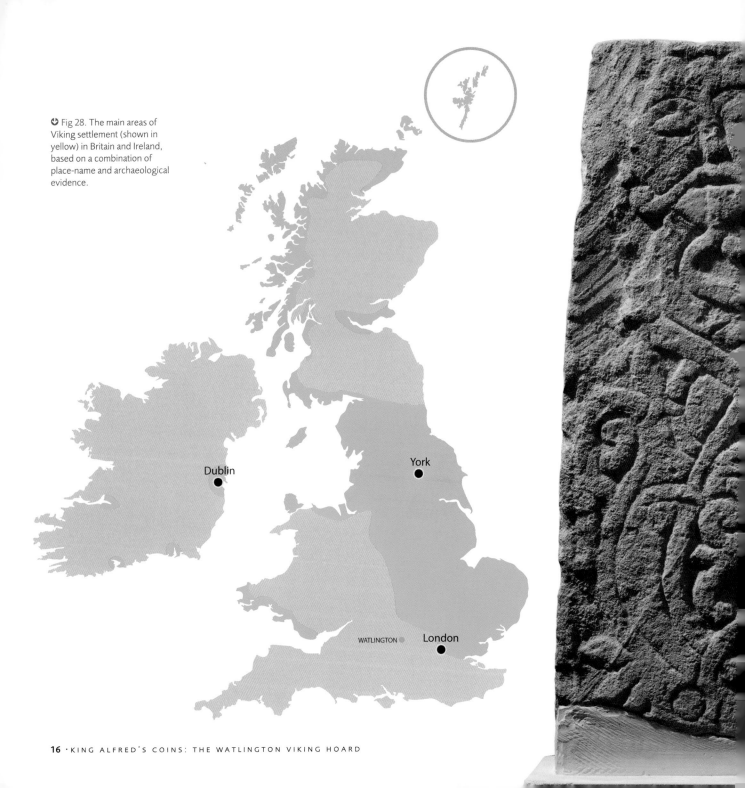

● Fig 28. The main areas of Viking settlement (shown in yellow) in Britain and Ireland, based on a combination of place-name and archaeological evidence.

Dublin

York

WATLINGTON

London

By this stage the *micel here* had already begun to divide and settle. In 876 one part of the *micel here* settled in the southern part of the kingdom of Northumbria, while the Vikings defeated at Edington settled in East Anglia. Others established themselves in northern and eastern Mercia. As a result, there was Scandinavian settlement across much of northern and eastern England. The legacy is still visible today, in many different ways. Place names of Viking origin are common, particularly in Yorkshire, the East Midlands, and the North-West, including Scandinavian personal names, as well as elements such as –by and –thorpe, both of which indicate types of settlement, as well as landscape features such as fell (hill, mountain), ness (headland), and beck (stream).

The Vikings are also visible through various groups of Anglo-Scandinavian sculpture which developed as a result of the mixture of Anglo-Saxon and Viking art styles, while Viking settlement can also be traced archaeologically. This is in part through the excavation of important Viking sites such as York and Lincoln (see Fig.24), but also through individual finds. These include jewellery, weapons and tools, coins, weights and other means of exchange, ranging from single finds to large hoards.

↻ Fig 29. Anglo-Scandinavian carved stone from Bibury, Gloucestershire. The design is in the Ringerike style, named after an area of Norway where this art style was also used.

↻ Fig 30. Twisted gold Viking arm-ring from Long Wittenham, Oxfordshire. Arm-rings are often found in hoards, but single finds are increasingly common.

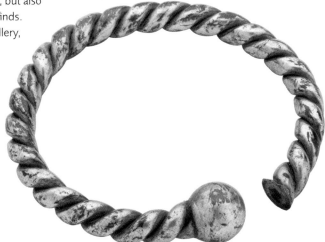

KING ALFRED AND THE VIKINGS

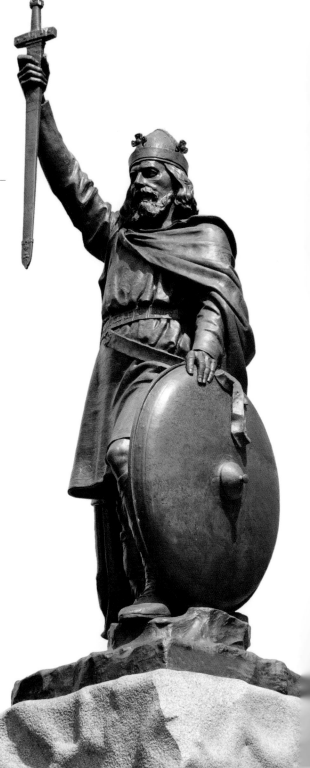

King Alfred of Wessex (871–99) is the only monarch in British history widely known as 'the Great'. His reputation derives to an extent from his success in defending Wessex from Viking attack, and from his integration of Wessex and the kingdom of Mercia into what was to become the kingdom of England.

Alfred was the youngest of the five sons of Æthelwulf of Wessex (839–58). It was only because his older brothers died young that he became king at all, and his first wars against the Vikings took place during the reign of his brother Æthelred (865–71). In 868, they led a West Saxon army to support their brother-in-law Burgred of Mercia against the Viking *micel here* at Nottingham, but were unable to dislodge the Vikings. In 870–71 Viking attentions turned to Wessex itself, and the brothers fought nine battles against them. As the *Anglo-Saxon Chronicle* puts it, 'sometimes one side had the victory, sometimes the other'. One of these battles, Ashdown, was a major victory; Æthelred and Alfred defeated the Vikings, killing two kings and five earls, as well as many of their followers. Ashdown was not decisive however, and the Vikings continued to raid Wessex for several months before withdrawing to Mercia.

Æthelred died in 871, probably of wounds received on the battlefield, and Alfred became king rather than Æthelred's son Æthelwold, who was still a child. Alfred then enjoyed a few years of respite while

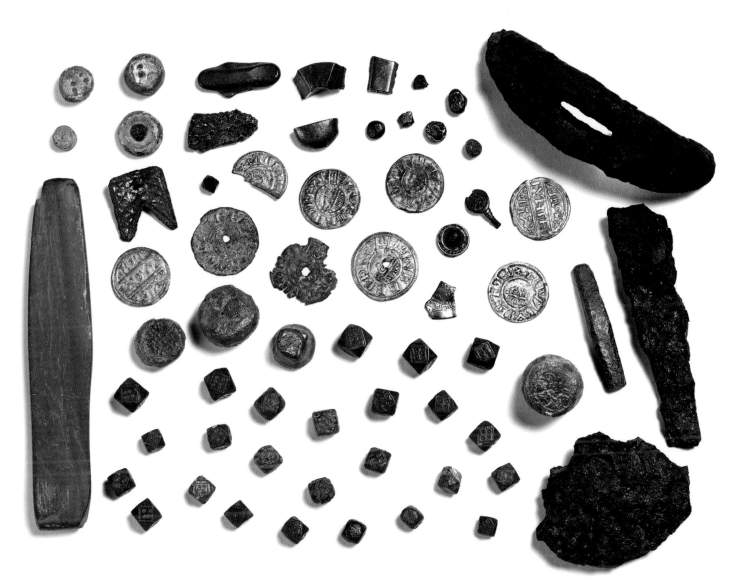

the *micel here* campaigned in Mercia (see p. 25). The *micel here* divided in 874, with part going north to Northumbria, and the other part to East Anglia, but the East Anglian army turned to Wessex again in 875, led by a king named Guthrum. A Viking force marched overland to Wareham in Dorset, where they were joined by a fleet sailing round the coast. A truce was established with Alfred, enabling them to stay there peacefully. This almost certainly involved a payment from Alfred, as well as the exchange of hostages. However, the Vikings broke the truce, and moved on to Exeter, but their accompanying fleet was destroyed in a storm off the coast near Swanage. Without the support of these ships and the supplies they carried,

↻ Fig 32. Finds from a Viking camp in Yorkshire, dating from around the time of the Viking settlement of Northumbria in 876. The finds include objects relating to production and exchange as well as warfare, while the size of the camp suggests the presence of thousands of men.

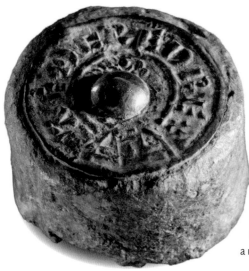

and with Alfred's forces in pursuit, the Vikings were unable to hold Exeter, and withdrew across the border to Mercia, establishing a base at Gloucester.

In the winter of 877–8 the Vikings returned and Alfred was apparently taken by surprise. The Vikings followed their usual practice of choosing a major royal estate or monastery as their winter base and attacked Chippenham, where Alfred was in residence. Alfred narrowly avoided capture, and Wessex was temporarily under Viking rule. Alfred spent the winter in hiding in the marshes of Athelney in Somerset. It is likely that the West Saxon nobles had to pay some sort of tribute to the Vikings, but much of the kingdom seems to have remained in West Saxon hands. Wessex had a well-established system of military organisation, mobilised on the basis of shires (forerunners of the modern counties). In the following spring, Alfred was able to summon the army from Somerset, Wiltshire, and part of Hampshire, and inflicted a major defeat on Guthrum's army at

↻ Fig 33. One of two Viking weights found near Kingston, close to Wareham in Dorset. The weight incorporates a coin of Æthelred I, and may be associated with the Viking presence at Wareham in 875–6.

↻ Fig 34. Athelney in the Somerset Marshes, where Alfred hid from the Vikings in the winter of 877–8.

Edington in Wiltshire. Guthrum was forced to abandon Chippenham and moved north into Mercia.

A few weeks later, Alfred made a peace-treaty with Guthrum at Wedmore. This involved Guthrum and many of his leading followers converting to Christianity. Guthrum himself took the baptismal name Æthelstan, with Alfred as his godfather. A surviving treaty between Alfred and Guthrum may reflect the outcome of the Wedmore meeting, which formed the basis of a lasting peace between the two kings. Alfred recognised Guthrum as king of East Anglia, and a border was established between their two kingdoms,

with arrangements for trade between the two. Although Alfred faced a number of further attacks from other Viking forces in the 880s and 890s, and these received some support from Viking East Anglia. The treaty with Guthrum was apparently largely successful, and Alfred had little trouble with Guthrum before his death in c.890.

Alfred introduced a number of reforms to defend Wessex against further attack. The first was the establishment of a network of fortifications known as *burhs*. These controlled access to all the major rivers and along the significant roads. At the same time, the

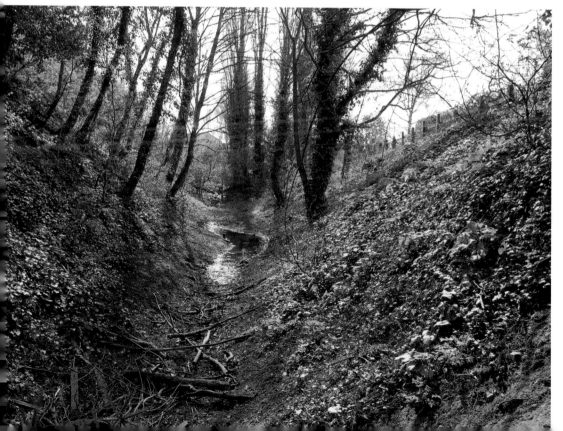

↵ Fig 35. Part of the bank and ditch defence of the *burh* of Wallingford, established by Alfred the Great.

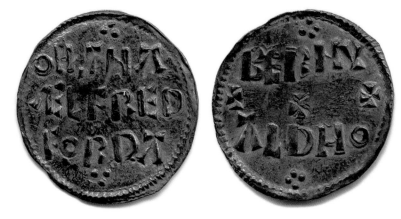

⊙ Fig 36. Silver penny of Alfred the Great, minted in Oxford. Alfred issued a number of coins carrying the names of important towns including London, Oxford, Exeter and Winchester. They may have been designed to celebrate the completion of defences in each town.

↻ Fig 37. The Alfred jewel, late ninth century. This is probably the handle of an *æstel*, or pointer, used to help follow text while reading. This example carries the inscription 'Alfred had me made', and Alfred is known to have given such objects as gifts to Churchmen.

burhs served as fortified supply dumps, denying the Vikings the chance to resupply themselves, while at the same time ensuring that the West Saxon army was never far from fresh supplies. The *burhs* themselves had permanent garrisons, which were capable of defending themselves, but which could also form part of a larger field army as needed.

Alfred also restructured the army, with only half the men on service at a time. The other half were free to carry on with their normal occupations, but were also immediately available to defend the areas around their homes. In a final reform, Alfred commissioned warships according to his own design to defend the coastline against attack, but was unable to prevent new Viking fleets arriving from the Continent.

Alfred's other defence measures were much more effective. Two major Viking fleets arrived in 892–3, but with little success. Although one group captured one of Alfred's *burhs* which had not yet been completed, the burghal system was generally successful, and the Vikings were repeatedly forced to retreat because of lack of supplies, on one occasion having to eat their own horses. A fortified bridge across the River Lea in 893 forced a Viking fleet to abandon their ships, some of which were then captured while the rest were destroyed. After repeated failures the Vikings abandoned their attacks on Wessex, and the final years of Alfred's reign seem to have been peaceful.

THE LOST KINGDOM

The kingdom of Mercia began as one of many small kingdoms, with its heartland around the River Trent. However, powerful Mercian kings such as Penda (d.655) and Wulfhere (658–76) were able to establish themselves as over-kings, demanding tribute from smaller neighbouring kingdoms in the Midlands, and even from major kingdoms as such as Northumbria and the kingdom of the East Angles.

In the eighth century, Mercia went from strength to strength, expanding across the land between the Thames and the Humber, with the exception of East Anglia. Under Æthelbald (716–57), Mercian overlordship was extended over East Anglia and Kent, and the old Roman city of London became a Mercian power centre. Under Æthelbald's successor Offa (757–96), East Anglia and Kent were conquered and brought under direct Mercian rule, and a large earthwork defence established along the frontier with Powys. It was also under Offa that defences are first recorded against Viking raids in Kent.

⊙ Fig 38. The Staffordshire hoard was buried in the late seventh century near Wall in Staffordshire, in the heart of the Mercian kingdom. Most of the items in the hoard are decorative parts of weapons, probably looted from a defeated enemy and symbolically destroyed.

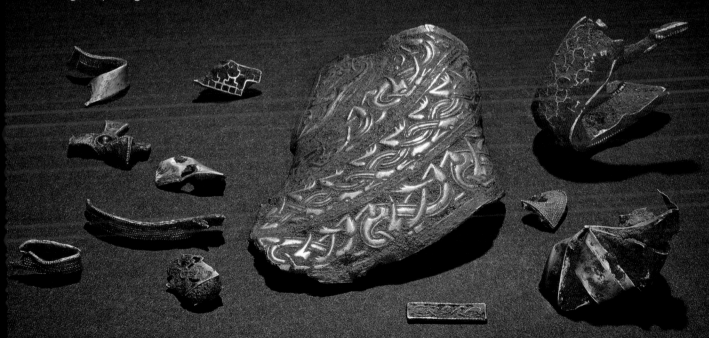

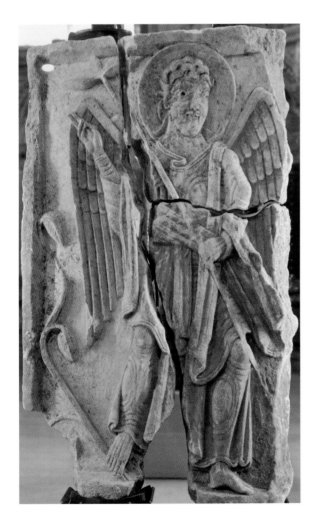

Offa's successor Coenwulf (796–821) maintained Mercian supremacy, and expanded his authority further into Wales. However, Coenwulf's death saw the end of Mercian dominance, his brother Ceolwulf I (821–3) losing all his brother's gains, while the kingdom of the West Saxons rose to prominence.

Under Alfred's grandfather Ecgberht (802–39), the West Saxons conquered first Kent in 825–6 and then Mercia in 829. Although the Mercian king Wiglaf recovered his kingdom in 830, he seems only to have ruled as a sub-king, under Ecgberht's overlordship.

The final decades of the Mercian kingdom saw a more co-operative relationship with the West Saxons, perhaps because both were facing increased threats

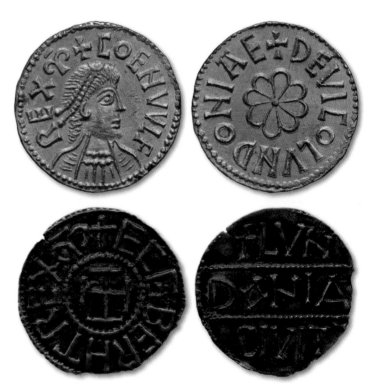

⊙ Fig 40. Coins of Coenwulf of Mercia and Ecgberht of Wessex. The rare gold coin of Coenwulf from London comes from the high point of Mercian power, but the silver penny of Ecgberht minted around twenty years later gives Ecgbehrt the title of king of Mercia, and celebrates his own control of London.

from the Vikings. Ecgberht's son Æthelwulf (839–58) established a monetary alliance with Berhtwulf of Mercia (840–56), and gave his daughter in marriage to Berhtwulf's successor Burgred (856–74), while Æthelwulf's youngest son Alfred married a Mercian noblewoman, Ealhswith. These marriage ties clearly formed part of a larger alliance, and Æthelwulf's son Æthelred (865–71) and his younger brother Alfred supported their brother-in law Burgred against the Vikings in 868 (see p. 18). Once again, political and monetary alliance converged, and first Æthelred and then Alfred issued coins following the designs of Burgred, who seems to have been the senior partner at this point.

All of this came to an end when the *micel here* invaded Mercia again, remaining in the kingdom for two consecutive years in 872–4. They over-wintered in 872–3 on an island at Torksey in Lincolnshire, and the following winter moved further up the Trent to the important monastery at Repton in Derbyshire, the burial place of a number of the Mercian kings. Apart from the monastery's wealth, its status as the Mercian royal mausoleum meant that its loss had an even greater symbolism than most churches captured or looted by the Vikings. Burgred abdicated, and went to Rome, where he died shortly afterwards, leaving much, if not all, of Mercia in the hands of the Vikings. However, the *micel here* divided in 874, with one part moving north to Northumbria, and another moving south to East Anglia, before attacking Wessex (see p. 19). Part of this latter group then went on to settle in eastern Mercia in 877.

Northern and eastern Mercia was now in the hands of the Vikings, but south-western Mercia remained Mercian, under the rule of Ceolwulf II. According to the *Anglo-Saxon Chronicle*, Ceolwulf was a 'foolish

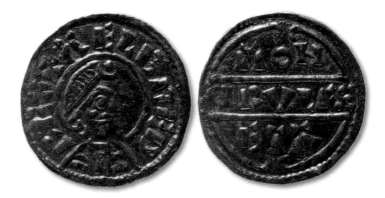

Fig 41. Silver penny of Alfred, *c*. 871–4. Alfred's first coin type, like the coins of his brother Æthelred I, was directly based on the coinage of his brother-in-law Burgred of Mercia.

Fig 42. Crypt of St Wystan's Church, Repton, Derbyshire. Repton was a royal foundation and the burial place of Mercian kings, and was seized by the Vikings in 873–4.

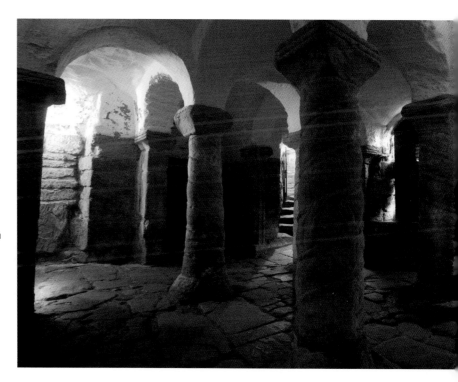

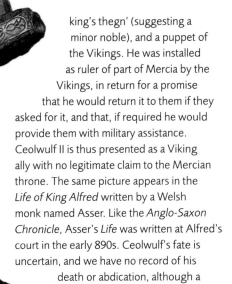

king's thegn' (suggesting a minor noble), and a puppet of the Vikings. He was installed as ruler of part of Mercia by the Vikings, in return for a promise that he would return it to them if they asked for it, and that, if required he would provide them with military assistance. Ceolwulf II is thus presented as a Viking ally with no legitimate claim to the Mercian throne. The same picture appears in the *Life of King Alfred* written by a Welsh monk named Asser. Like the *Anglo-Saxon Chronicle*, Asser's *Life* was written at Alfred's court in the early 890s. Ceolwulf's fate is uncertain, and we have no record of his death or abdication, although a list of Mercian kings preserved at Worcester tells us that he reigned for around five years, suggesting that his reign ended *c*.879.

There are several problems with this version of events. Firstly, although there are no records of Ceolwulf's descent, it seems likely that Ceolwulf II was a descendant of the branch of the Mercian dynasty that had produced Coenwulf and Ceolwulf I. Ceolwulf II was also apparently accepted by the Mercian nobility, and issued charters as king, with Mercian bishops and nobles as witnesses, and with no suggestion that he was in any way subject to any other

G Fig 43. The Abingdon sword, Anglo-Saxon, late ninth or early tenth century. The sword shows the wealth available to the nobility of southern Mercia around the time of Alfred and Ceolwulf II.

ruler. Furthermore, he was able to issue an extensive coinage in his own name. Like the charters, this is typical of an Anglo-Saxon king ruling independent of any overlord.

The coinage in particular suggests a very different picture of Ceolwulf's relationship with Alfred. Monetary alliance between Wessex and Mercia was nothing new (see p. 25), and both of the types issued in Ceolwulf's name were also issued by Alfred, in some cases apparently in the same towns by the same moneyers. The sense of alliance is strengthened by the use on one type of a Roman design showing two emperors side by side, with a winged figure of Victory above them (see p. 8). This winged figure may well have been interpreted by the Anglo-Saxons as an angel rather than Victory, but either way its presence together with the two rulers is probably significant. If interpreted as an angel, it suggests that the West Saxons accepted that Ceolwulf was king of Mercia with God's blessing. If it signifies Victory, the coinage may have been struck to commemorate a shared victory which later West Saxon sources either fail to mention, or credit to Alfred alone. The sense of common purpose is also reinforced by the fact that the two kings increased the silver content of the coinage significantly from that found in the coins of Burgred and the early part of Alfred's reign. The monetary alliance also included the archbishop of Canterbury, who also issued coins of related designs and silver standards during this period. This again affirms Ceolwulf's acceptance not just by Alfred, but by the Church.

The coinage indicates a very different picture of the relationship between Alfred and Ceolwulf from the one given in the written records from Alfred's court. That has been recognised by historians for many

years, but the Watlington hoard now demonstrates clearly that the coinage was much more substantial than was previously recognised, and it may well have lasted throughout the whole of Ceolwulf's reign. The fact that the later types of Alfred's reign were barely represented in the hoard indicates that there was little overlap between the two phases of coinage, and therefore reinforces the existing interpretation that those coins only began to be issued after Ceolwulf's 'disappearance'.

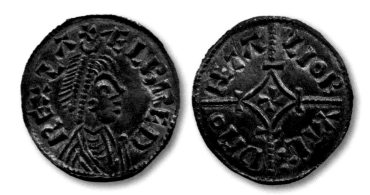

The hoard does not tell us what became of Ceolwulf, but the absence of any reference to what happened may be significant in itself. Alfred promoted a new image of a combined kingdom of Angles and Saxons – it is this that gives us the concept of 'Anglo-Saxons' today – representing the populations of Mercia and Wessex respectively. His law codes drew on what he regarded as the 'best' laws of Mercia, Kent, and Wessex, helping to combine all three kingdoms together as one. In the latter part of the reign Mercia was ruled not by a king, but by an ealdorman, a lesser role directly subordinate to the king. Alfred's ealdorman of Mercia was Æthelred, who was married to Alfred's daughter Æthelflæd. Æthelred continued in the same role under Alfred's son Edward the Elder (899–924), and following Æthelred's death in 911, his widow Æthelflæd continued to rule Mercia in her brother's name as the 'Lady of the Mercians', gradually reconquering many parts of Mercia which had been lost to the Vikings. However, these were added not to a resurgent kingdom of Mercia, but to Edward's emerging kingdom of England, which Edward himself also extended into East Anglia and the East Midlands.

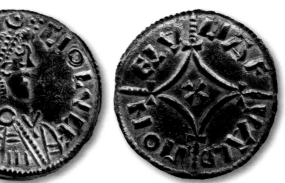

⊙⊙⊙ Fig 44. Coins of the Cross-and-Lozenge type from the hoard, in the names of Alfred of Wessex, Ceolwulf II and Archbishop Æthelred of Canterbury. The shared coinage suggests a mutual respect and perhaps active alliance.

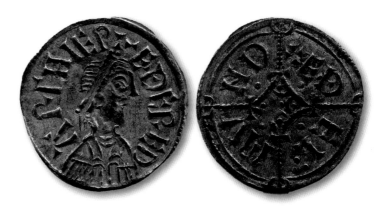

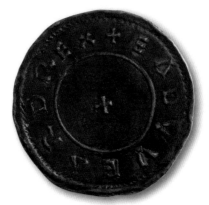
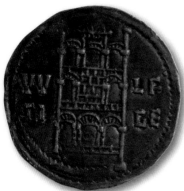

⊙ Fig 45. Silver penny of Edward the Elder, probably minted in northern Mercia. The design may show a church tower or a fortification, but either way it represents the re-establishment of Anglo-Saxon royal authority into an area held by the Vikings for forty years or more.

Against this background of the West Saxon takeover of Mercia, the former alliance between Alfred and Ceolwulf became an embarrassment, and perhaps even a barrier to Alfred's claims in Mercia. The dismissive remarks about Ceolwulf are only recorded a decade or more after he disappears from the record, and may represent a deliberate attempt to rewrite history in a way that suited the politics of the time. A further re-coinage c.879–80 meant that most of the coins of Ceolwulf's reign were melted down and recycled, removing the one publicly visible reminder of the alliance. The silence in the historical record about the circumstances of Alfred's takeover of Mercia suggests that it lost its independence in ways which were not entirely creditable to Alfred.

This does not diminish Alfred's achievements, and his success in defending Wessex against the Vikings after near defeat cannot be overestimated. Nevertheless, the Watlington hoard is a profoundly important piece of evidence that Alfred's role in the politics of the time was more complex than his accepted status of national hero suggests. If Mercia was lost as an independent kingdom, it was lost at least in part because this was of benefit to Alfred.

THE HOARD IN CONTEXT

The Watlington hoard emerges as a rare piece of evidence from the moment when the great kingdom of Mercia disappeared forever, while Wessex under Alfred the Great managed to snatch victory from the jaws of defeat. Alfred not only defended Wessex successfully against the Vikings, but expanded his authority into Mercia, laying the foundation for what became the kingdom of England under his descendants. The presence in the hoard of a single coin of Alfred's Two-Line type suggests that the hoard was buried around the time that Alfred introduced that coinage, in c.879–80, and thus around the time of Ceolwulf's disappearance. That does not in itself explain the presence of a Viking hoard in South Oxfordshire.

A fact that may relate in some way to both the hoard and to Ceolwulf's disappearance is that following Alfred's defeat of Guthrum's army at Edington in 878, Guthrum's army moved north to Cirencester in southern Mercia, where they based themselves for a year. Their prolonged presence in south-west Mercia, the heartland of Ceolwulf's power, must have been devastating for Ceolwulf's position, and there may have been battles between the Vikings and the Mercians which the *Anglo-*

Saxon Chronicle does not trouble to record. Guthrum's peace treaty with Alfred says nothing of the situation in western Mercia, but Alfred was the eventual beneficiary of whatever happened there, and there are numerous examples of Christian rulers using the Vikings as allies against their rivals. We do not know that such an alliance took place between Alfred and Guthrum, however we cannot rule it out.

Whatever the politics of the period 878–9, Guthrum's army moved in 879 from Cirencester to East Anglia, where Guthrum then ruled as king for around ten years, under his baptismal name of Athelstan. A large army could only have progressed along a limited number of major routes. These were restricted to re-used Roman roads, and a small number of probably

⬆ Fig 46. Map showing the movements of Guthrum's army, 875–879.

pre-Roman trackways. Among these was the great trackway known as Icknield Street or Icknield Way, which extended from Wiltshire to Norfolk. The last part of Guthrum's journey will almost certainly have been along the Icknield Street, at least from the Buckinghamshire border. To get there from Cirencester, there were two main possible routes. One was a Roman road which extended eastward from Cirencester, running to the north of Oxford and continuing to St Albans. The second route involved another Roman road heading south east from Cirencester, and meeting the Icknield Street much earlier. This section of the Icknield Street, more commonly known today as the Ridgeway, runs through South Oxfordshire and right through the Watlington area.

We do not have any firm evidence that the hoard was buried as a direct consequence of the Vikings' movement from Cirencester to East Anglia in 879, but it seems likely. At the very least, the hoard must be seen in the context of Viking activity in the south Oxfordshire borderlands between the ancient kingdoms of Mercia and Wessex, and at a time when the former kingdom was being swallowed by the latter.

Further research is needed on the hoard to establish a clearer picture of exactly when and why it was buried. Detailed study of the coins will also help to unravel the mystery of the relationship between Mercia and Wessex in the period that saw the final collapse of the old order, and the emergence of what was to become the kingdom of England. While the hoard still has more to tell us, it is already clear that it is an important national treasure, shedding light not only on the fight to preserve England from Viking conquest, but on the creation of England itself.

Fig 47. A range of objects from the Watlington Hoard.

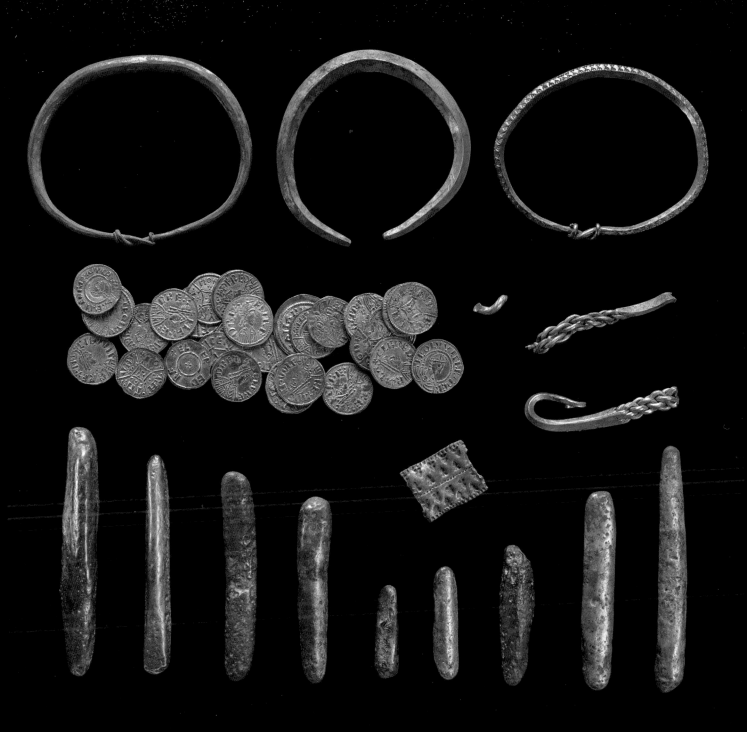

Further reading

Abels, R., *Alfred the Great: War, Kingship and Culture in Anglo-Saxon England* (London, 1998)

Blackburn, M.A.S., and D.N. Dumville eds., *Kings, Currency and Alliances: History and Coinage of Southern England in the ninth century* (Woodbridge, 1998)

Brown, M.P., and C.A. Farr, *Mercia: an Anglo-Saxon Kingdom in Europe* (London and New York, 2001)

Carroll, J., S.H. Harrison, and G. Williams,*The Vikings in Britain and Ireland* (London, 2014)

Graham-Campbell, J., *The Cuerdale Hoard and related Viking-Age silver and gold from Britain and Ireland in the British Museum* (London, 2011)

Hinton, D.A., *The Alfred Jewel and other later Anglo-Saxon decorated metalwork* (Oxford, 2008)

Keynes, S. and M.Lapidge, *Asser's Life of King Alfred and Other Contemporary Sources* (Harmondsworth, 1983)

Reuter, T., *Alfred the Great* (Aldershot, 2003)

Swanton, R. ed. and trans., *The Anglo-Saxon Chronicle* (London, 1996)

Williams, G., *Early Anglo-Saxon Coins* (Princes Risborough, 2008)

Williams, G., and B. Ager, *The Vale of York hoard* (London, 2010)

Acknowledgements

This book has been written to help with fundraising for the acquisition and display of the Watlington hoard. Its publication was generously sponsored by the Carl and Eileen Subak Family Foundation. The authors would also like to thank the following individuals and institutions, without whose help this book would not have been possible: Barry Ager, Carol Anderson, Neil Christie, Chris Howgego, Ryan Lavelle, Michael Lewis, James Mather, David Moon, Pippa Pearce, Johanne Porter, Ian Richardson, Eleanor Standley, David Williams, the Trustees of the British Museum, Oxfordshire Museum Services , the Chapter of Lichfield Cathedral, and the York Archaeological Trust.

Picture credits